Start with Art

Prints

Isabel Thomas

Heinemann Library
Chicago, Illinois

 www.heinemannraintree.com
Visit our website to find out more information about Heinemann-Raintree books.

To order:
☎ Phone 888-454-2279
💻 Visit www.heinemannraintree.com to browse our catalog and order online.

© 2012 Heinemann Library
an imprint of Capstone Global Library, LLC
Chicago, Illinois

Edited by Dan Nunn, Rebecca Rissman, and Catherine Veitch
Designed by Richard Parker
Picture research by Hannah Taylor and Mica Brancic
Originated by Capstone Global Library
Printed and bound in China by South China Printing
 Company Ltd

15 14 13 12 11
10 9 8 7 6 5 4 3 2 1

Library of Congress Cataloging-in-Publication Data
Thomas, Isabel, 1980-
 Prints / Isabel Thomas.—1st ed.
 p. cm.—(Start with art)
 Includes bibliographical references and index.
 ISBN 978-1-4329-5019-4 (hardcover)—ISBN 978-1-4329-5026-2 (pbk.) 1. Prints—Technique—Juvenile literature. I. Title.
 NE860.T48 2011
 769—dc22 2010042680

Acknowledgments
We would like to thank the following for permission to reproduce photographs: Belfast Print Works p. 13; © Capstone Global Library Ltd p. 10 (Tudor Photography); © Capstone Publishers pp. 8, 20, 21, 22 left, 22 right, 23 – transfer (Karon Dubke); © Corbis p. 16 (Michael S. Wertz); Corbis p. 9 (© Penny Tweedie), 11 (© Philadelphia Museum of Art); M.C. Escher's "Development II" © 2010 The M.C. Escher Company- Holland. All rights reserved www.mcescher.com p. 19; Photolibrary p. 7 (John Warburton-Lee Photography/ John Warburton-Lee); Scala p. 17 (Museum of Modern Art, New York); Shutterstock pp. 4 (© Katrina Brown), 15, 23 – abstract (© Elena Ray), 23 – texture (© Konstantin Sutyagin), 23 – textile (© afaizal), 23 – surface (© Evgenia Sh.), 23 – subject (© Nastenok), 23– gallery (© Shamleen); The Bridgeman Art Library pp. 5 (Haags Gemeentemuseum, The Hague, Netherlands), 6 (© Fry Art Gallery, Saffron Walden, Essex, UK), 12 (© The British Sporting Art Trust/Private Collection), 14 (© Christie's Images), 18 (Private Collection).

Front cover photograph of 18th-century head of a woman by Kitagawa Utamaro reproduced with permission of Corbis (© The Gallery Collection). Back cover photograph of children's hand prints reproduced with permission of Shutterstock (© Katrina Brown). Back cover photograph of rolling paint over a leaf reproduced with permission of © Capstone Publishers (Karon Dubke).

Contents

Some words are shown in bold, **like this**. You can find out what they mean by looking in the glossary.

What Is a Print?

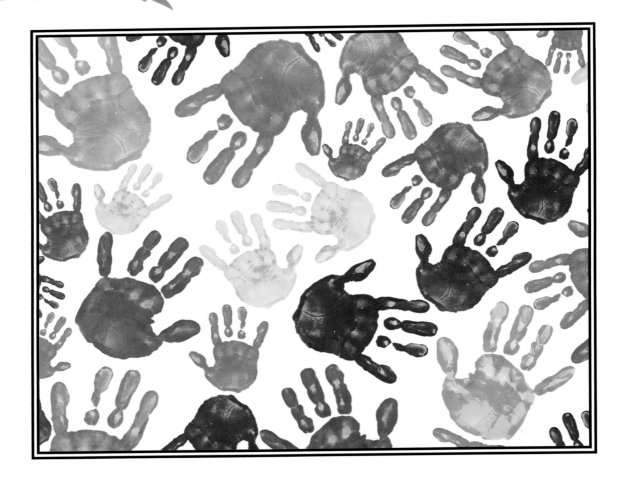

A print is the mark you make when you cover something in paint and press it on to paper.

You can use printing to make the same mark again and again.

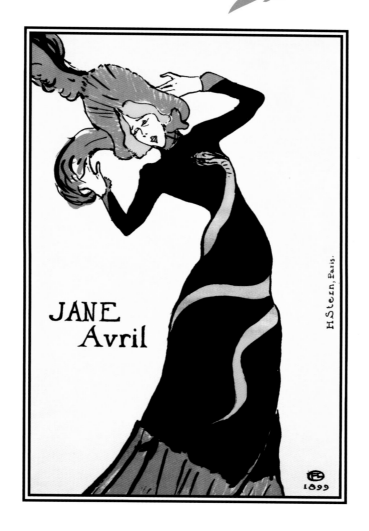

Some artists use printing to make pictures.

They can print many copies of the same picture.

Where Can I See Prints?

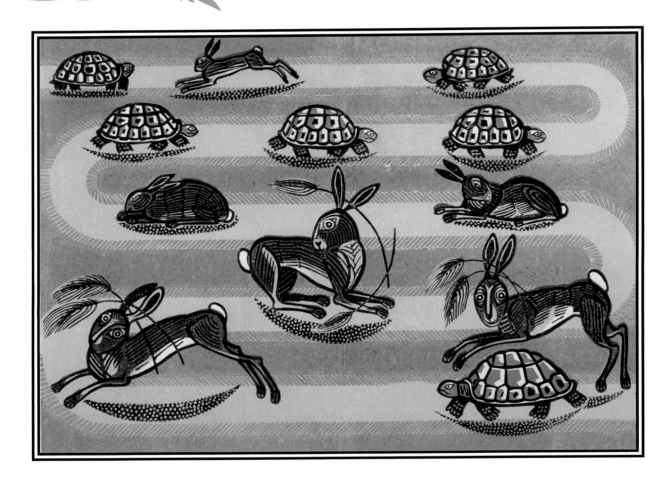

Museums collect prints from different times and places.

Some prints made by artists are displayed in **galleries**.

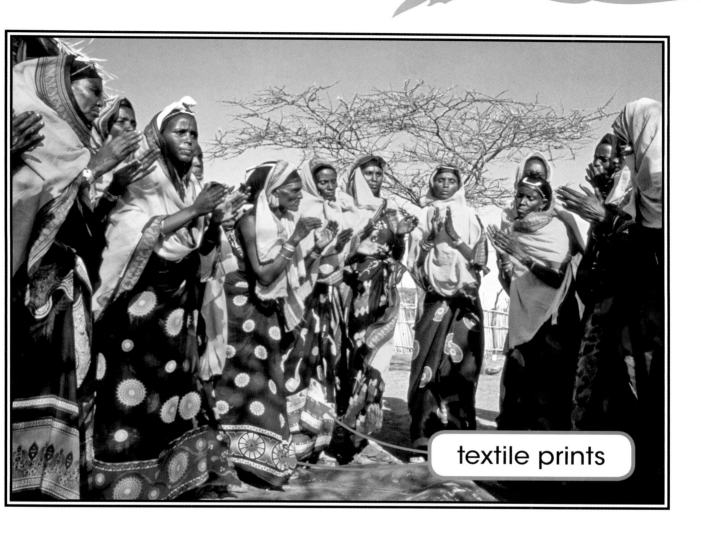

textile prints

You can see prints all around you, too.

People use printing to decorate **textiles** and many other things.

What Do People Use To Make Prints?

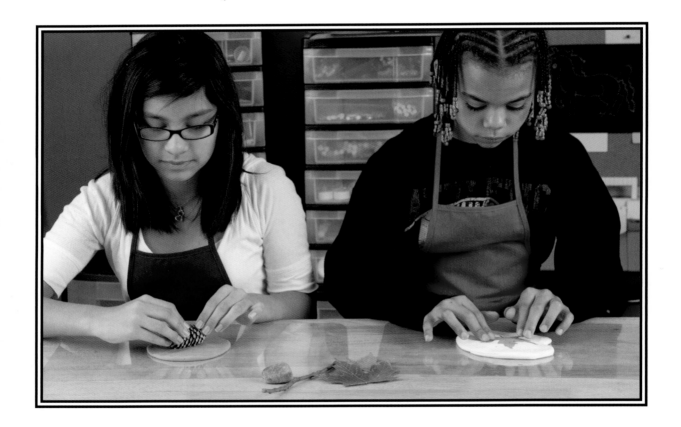

You can dip an object in paint and press it on to a flat **surface**.

You can print shapes on a soft surface, such as clay.

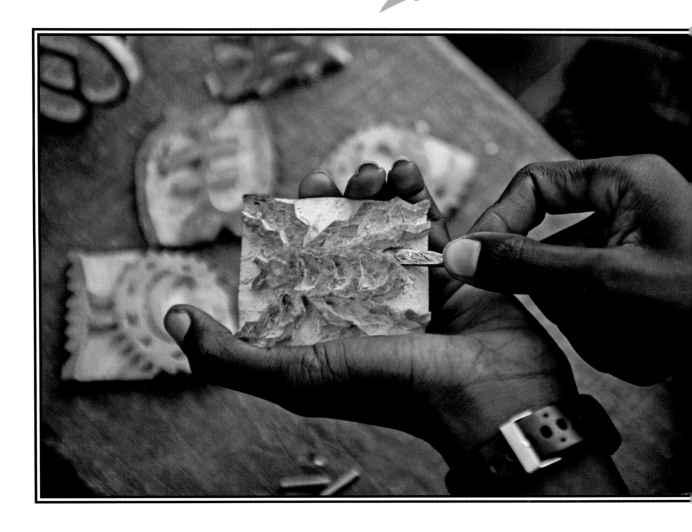

Artists scratch, carve, or draw a picture on to a special surface.

They use printing to **transfer** the picture on to a new surface, such as paper.

How Do People Make Block Prints?

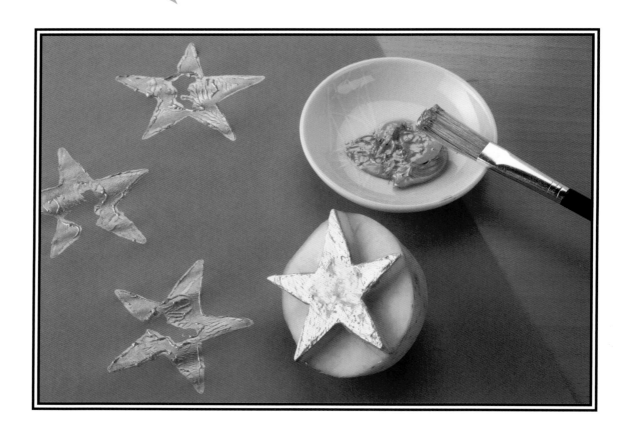

Have you ever made potato prints?
This is a kind of block printing.

Artists carve a design into a block
made from wood or another material.

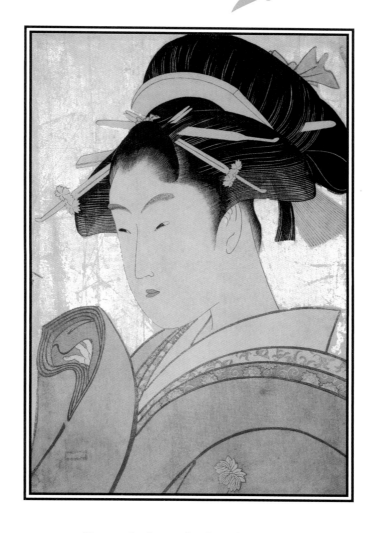

They cover the block in ink and press
it on to paper or fabric.

This print of a Japanese lady was
made over 200 years ago.

How Do People Use Texture in Prints?

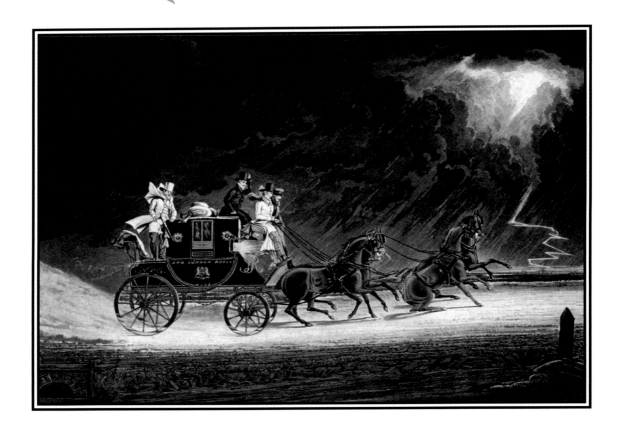

Prints can look very different from drawings and paintings.

This print uses **texture** to show shiny horses, rough ground, and stormy weather.

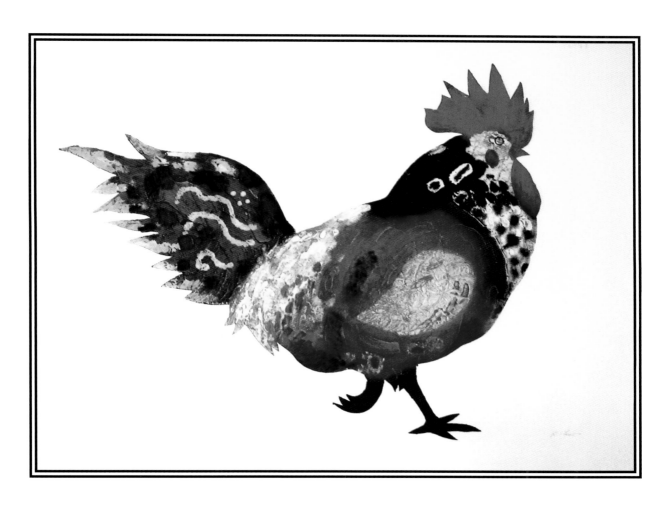

This picture was printed from
a collage.

The artist used different **textures** to
show the rooster's feathers.

What Do Prints Show?

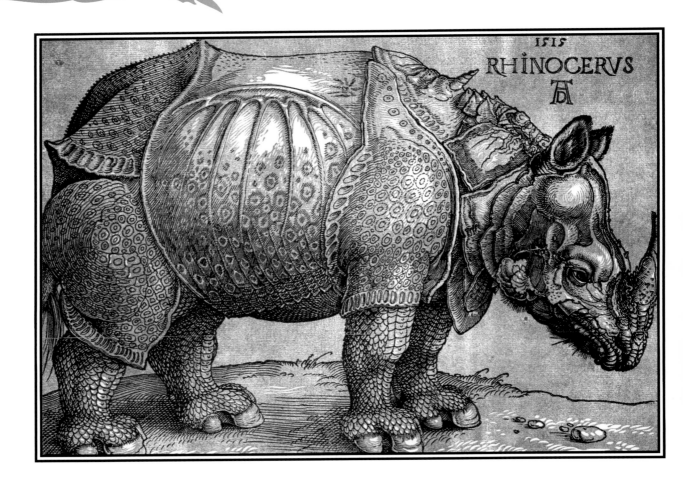

Some artists make prints of real things, such as animals.

This print shows the **texture** of wrinkly rhino skin.

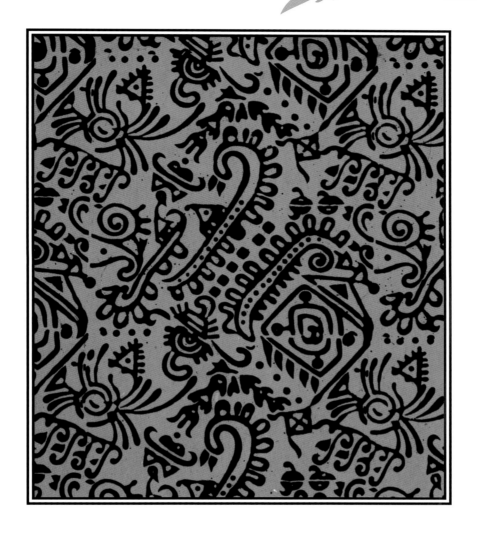

Some artists make **abstract** prints to show ideas and feelings.

What do the shapes in this picture make you think and feel?

How Can Prints Show Ideas and Feelings?

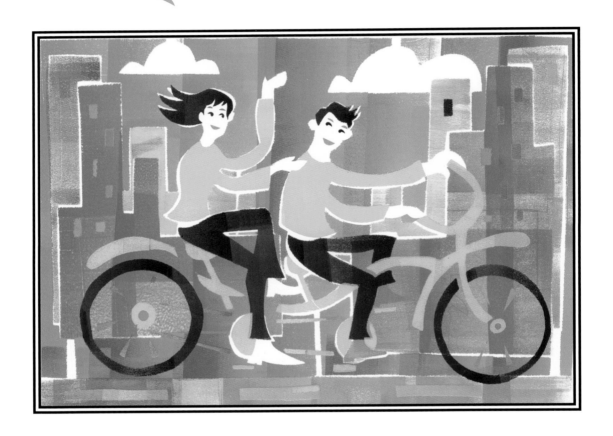

Artists use colors, shapes, and **textures** to tell us about their **subject**.

Flat shapes and bright colors make these people look happy and lively.

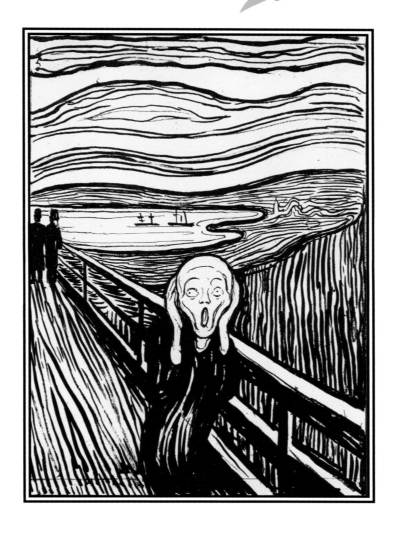

This print has jagged lines and
no colors.

Do you think the person feels happy,
angry, sad, or scared?

How Do People Use Pattern in Prints?

The same marks can be printed many times to make a pattern.

Printing is used to decorate pottery, wallpaper, and **textiles**.

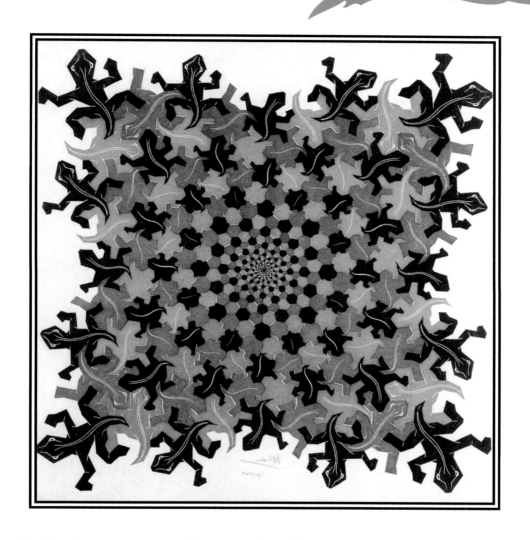

Artists use patterns in their
pictures, too.

Shapes turn into lizards in this print.

Start To Print!

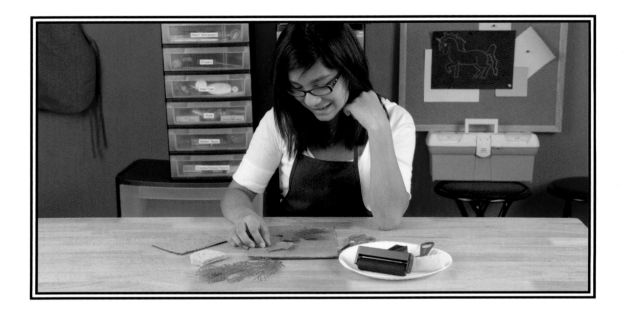

The print on page 13 is made from a collage. You can make one, too!

1. Collect materials with interesting **textures**. Use things that you might throw away, such as sponge, **textile** scraps, cardboard, and leaves.

2. Arrange the materials to make a collage picture of an animal.

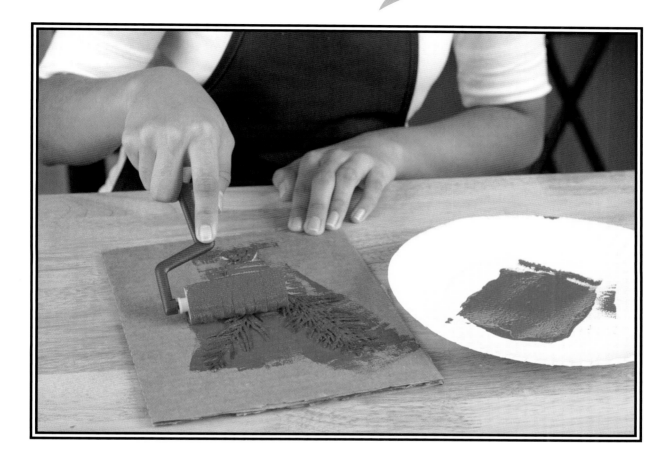

3. When you are happy with your design, glue the materials on to a piece of thick cardboard. Make sure that they are all about the same height.

4. Use a roller to cover your collage in ink.

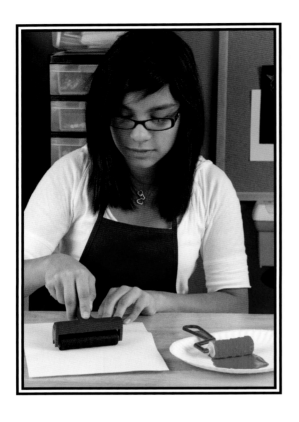 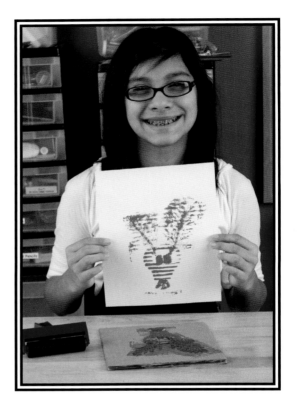

5. Put a sheet of paper over the inked collage. Roll a clean roller over the paper to make a print.

6. You can make more copies of your picture by doing steps 4 and 5 again.

Glossary

abstract type of art where the shapes and colors show ideas and feelings instead of real things

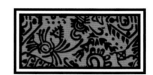

gallery place where art is displayed for people to look at

subject person, place, or object shown in a piece of art

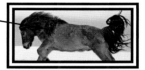

surface something that an artist prints on, such as paper, cardboard, clay, fabric, or wood

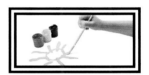

textile material or fabric, used to make clothes and other things

texture how a surface looks and feels

transfer move something from one place to another. Printing moves a picture from one surface to another.

Find Out More

Websites

See all the different ways to make prints on this Website:
www.moma.org/interactives/projects/2001/whatisaprint/print.html

Print your own wallpaper design on this Website:
www.vam.ac.uk/vastatic/microsites/1185_families/flash/

Index